Creative
EXPLORATION

A SIX WEEK PROCESS
FOR INTRODUCING
REGULAR CREATIVITY
INTO YOUR LIFE

By: Eileen McKenna

For my family, for always supporting
my creative explorations.

Creative Exploration: A Six Week Process for Introducing Regular Creativity into your Life
by Eileen McKenna

Second Edition

www.mycreativeresolution.com, eileenmckenna.com/shop

ISBN 9781694628763

Cover art and design by Eileen McKenna.

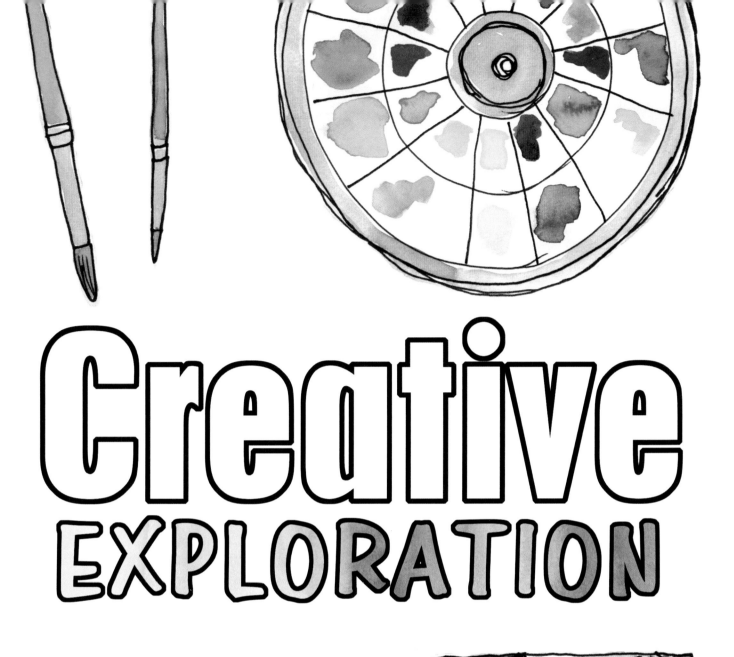

Creative
EXPLORATION

A SIX WEEK PROCESS
FOR INTRODUCING
REGULAR CREATIVITY
INTO YOUR LIFE

By: Eileen McKenna

TABLE OF CONTENTS

Introduction

WHO THIS BOOK IS FOR

Are you pinning projects on Pinterest, but never doing them? Scrolling and liking other people's work on Instagram, all the while wishing you could—or would—do something?

This book is for anyone who wants to inject creativity into their life: regular creativity, where almost every day you take creative action; every week you have a project in the works; and you're excited about what you're working on or the new thing you're trying.

You might be saying, "I want that, but I'm not talented enough." Realize that talent is just a starting point. Want to learn how to draw, paint, or whatever medium interests you? Work at it on a regular basis. Practice being creative. This book will show you how.

Creativity is for everyone. It's meditative and therapeutic to put lines on a page, strokes on a canvas, to mold clay into something, etc. It doesn't matter what the end result looks like. My first creative goal as an adult was to learn to draw more realistically. I achieved my goal but realized the real joy came not from my finished piece, but from the time spent being creative.

Every time I drew or painted, I experienced joy. Despite understanding this, it took a few more years before I was able to incorporate regular creativity into my life.

The process laid out in this book is about exploring different mediums in the pursuit of "your thing." It's about opening yourself up to—and finding—inspiration, and the subjects that speak to you. It's about learning to focus your ideas and tasks, so you are finishing projects and working towards your creative goals.

It's about being creative and finding joy.

HOW TO USE THIS BOOK

This book is broken down into 6 weeks, with week 6 looking forward into the period beyond the 6th week. Each week, read through that week's tips and step-by-step creative exercises before beginning. Follow the steps, exercises, and tips that are outlined, and you will develop a regular creative practice.

Try not to be intimidated by the term "creative practice." I admit that I have had issues with this term in the past—I found it challenging, similar to calling oneself an artist. I find the term "practicing creativity" more approachable. That's what I do. I simply sit down, experiment, and explore. I practice creativity. That's the goal of this book. Anyone can do it!

MY CREATIVE STORY

I wanted to be an artist when I grew up. Doesn't everyone? In high school I planned on majoring in art in college. But without anyone to guide me on a creative path, and with a lack of confidence in my "talent," I ended up majoring in Business Management.

During senior year of college I realized the error of my choice when I took an elective in the art department. I knew I needed a career that involved creativity. Luckily I ended up working in New York City, with access to several art schools. I took classes in graphic design and changed jobs a few times, finding a more creative job with each move.

Finally my business card said "Graphic Designer" and then "Art Director." But one thing made me feel self-conscious: I couldn't draw. If anyone called me a graphic artist, I corrected them, and said graphic designer. I felt uncomfortable using the title "artist."

After having kids, I stayed home, and freelanced on the side. Twice a year, a continuing ed catalog would arrive, advertising local creative classes, including "The Art of Drawing." For years, I was disappointed because I couldn't make the class work with my parenting schedule. Finally, after my third child was born, I committed to making the time and signed up. When I drew a bear in colored pencil and proudly showed it to my husband, I was bursting with joy: "I made this!"

MY CREATIVE RESOLUTION

After a few years of continuing ed classes in drawing and painting, I decided it wasn't enough. I wanted to be creative on a regular basis, not just once a week for six weeks. I also wanted to do my own thing, to explore what interested me. I wasn't quite sure what that would be, but I was very excited about the freedom, and the limitless possibilities.

I couldn't wait to find out. I had so many ideas! But it wasn't the first time I started a new year with a new sketchbook, committed to doing something creative. This time I started a blog to hold myself accountable. I called it "My Creative Resolution," and it changed everything.

It's been over five years since I made My Creative Resolution. I continue to practice creativity regularly, and I share what I'm working on almost daily on Instagram @eileenmckenna. I blog a few times a month, sharing my work and thoughts on creativity. I also have a weekly newsletter, which is a collection of wonderful things that inspire me. Sign up at www.mycreativeresolution.com/newsletter.

Making My Creative Resolution and starting my blog was the best thing I could have done. I learned to:

- Self motivate
- Try new mediums
- Look for and "see" inspiration
- Learn from others
- Develop my own style
- Evolve and grow
- Find out more about myself
- Put myself out there
- Experience the joy creativity brings
- Increase my confidence
- Meet others who encourage and inspire me

Quite unexpectedly, I became someone who inspired the next set of people starting their creative journeys.

I never would have done all of these things — and finished so many projects — without a regular creative practice. I developed systems to stay on track, focus, and finish projects. This is what I want to share with you.

My Creative Resolution has taught me so much and continues to until this day. I'm still on a creative journey, and that's the exciting and fun part. I can't wait to help you get started on yours!

CREATIVE REFLECTION

Before you start, it's important to think about your creative history. Many of us have had experiences where comments from others have affected our confidence and our feelings of worthiness regarding creativity.

For most of my life I lacked the confidence to put myself out there. I thought, "What if I pursued art, wasn't any good, and people made fun of me?" These thoughts may sound silly (or completely familiar). I realized the fear of being made fun of was holding me back. Finally in my 40's, I arrived at a place where I decided I wanted to be creative for me, because of how it made me feel. What other people thought wasn't as important. I thought, "If not now, when?" But even when I first started the blog, I stayed anonymous and only told my immediate family. Over time, I learned that sharing my work wasn't scary, and that most comments were positive and encouraging. It took a little while, but eventually I revealed who I was, and became proud to tell others what I was doing.

I remember being really young and making a "picture" with crayons. I think it was a Christmas tree with presents, but whatever it was, I used a lot of purple. I purposely made it look "ugly." When I showed it to my mom, she said, "Beautiful!" and I said, "I knew you were lying to me!" Wisely, she said, "Just because you think it's ugly doesn't mean I do." I wonder about that moment. What made me question the praise she always gave me? Was I already questioning myself?

I was considered pretty creative in my younger years. I loved art class in elementary school. When Mrs. Kareska pushed the cart filled with art supplies into our room I would be bursting with excitement. I recall a project where we were given tissue paper to use to create Christmas cards. The tissue paper was to mimic stained glass. Immediately I had the idea of a wreath with berries on a door. I remember the thrill of realizing my vision.

In high school art class I became aware that other people were more "talented" than I was. One girl, Peggy, drew the most amazing pencil portraits. The shading was incredible. Thinking back on it now, I know that I couldn't have created those with the skills I had at that time. But it has dawned on me that if I had practiced and learned shading and other techniques, I could have created my own version of portraits that would have made me proud. At the time, I just assumed Peggy could do amazing

portraits and I couldn't. This limited view also cropped up when thinking about my athletic abilities: I was a swimmer, and I assumed my ability was set in stone. I never realized that I could work harder, train differently, learn better techniques, and improve.

I tried to get back on track my senior year of college by approaching my art professor. When I asked her how I could become a graphic designer, she showed me a magazine of award-winning designs and said, "You need a portfolio that looks like this." Flipping through it, I concluded I could never create that stuff—everything looked so slick and glossy. I hadn't even heard of Photoshop yet. In my head I said, "Oh well." It wasn't until I started working and yearning to be in the art department that I revisited the idea. I decided to pursue it, not because I thought I'd be any good, but because I figured there was plenty of terrible design out there, and if it made me happy, who cares?

YOUR CREATIVE STORY

What experiences in your life have shaped your attitude towards creativity and your own abilities?

What has held you back?

What is your biggest creative fear?

Is there a personal trait or habit that has hindered your creative practice?

When I started the blog and began creating, I had the extra motivation of sharing finished projects online. I recognized that in the past I was very quick to quit. If a project didn't look good, I'd toss it aside. Now that I was sharing my projects and progress online, I couldn't just toss stuff aside. I was forced to finish, and finishing taught me that all projects have hard phases that you have to push through. Finishing projects became a motivator for finishing future projects. I was able to change my work habits. Now when I get to the hard part in a project, I no longer quit—I expect that tough part and am practiced in working through it.

How about you? Do you quit when a project gets tough? Or do you have other habits that hinder your creative practice?

What is your current attitude towards your own creativity?

LOOK FORWARD NOT BACK

As much as we let our experiences define us, they don't have to. In the book, *Real Artists Don't Starve,* Jeff Goins says, "At any point in your story, you are free to re-imagine the narrative you are living. You can become the person you want to be."

Should I not draw because back in high school someone was better? Should I have not become a graphic designer because in college the professor wasn't encouraging? Should I not paint because someone might laugh? Or should I get excited about a new creative project, just like the little girl watching the art teacher push the cart filled with art supplies into the room?

After reflecting on your creative experience, try turning the page on the negative ones and start writing new positive ones.

CREATIVE GOALS

When I started my blog one of the first things I wrote was, "I hope to draw, paint, and create my way through 2014!" I had no real thought about what I would end up working on. I thought I might become a furniture refinisher. Ha ha! I didn't. I barely did one piece. My interests took me in other directions.

My goal was to learn what I would work on if I was given total creative freedom, with no teacher or classmates to influence me.

Think about your creative goals. Why did this book interest you?

What do you want, creatively speaking?

What do you dream of doing?

Why is being creative important to you?

Write your creative goals here:

YOUR CREATIVE PROJECT IDEAS

As you start your creative journey, it is important to collect all the creative project ideas you've had rolling around in your head. Collecting them in one spot is the first step in focusing on the ones that call to you most.

Write down all of the creative project ideas you have. Try not to limit yourself; think both broadly and specifically.

Write all of your creative project ideas here:

CREATIVE INTERESTS

The process in this book is divided into six weeks. Each week involves daily (or almost daily) short creative practice sessions and a longer creative project that is spaced out across a few days. Each week involves exploring a different medium.

The main objective is regular creativity, with creative goals such as:
- Short warm-up practice sessions
- Time to explore different mediums
- Choosing a creative project
- Dedicating time to working on and finishing the creative project

The mediums I suggest mimic my own journey:
- Week 1 - pencil
- Week 2 - colored pencil
- Week 3 - watercolor
- Week 4 - ink (with or without watercolor)
- Week 5 - acrylics

So far, my interests are primarily in drawing and painting. However, I have also tried other things like block printing, animation, and designing fabric prints.

Your journey should reflect what interests and attracts you. While trying and exploring mediums is great, there are so many of them. Choose what intrigues you!

MEDIUMS & YOUR CREATIVE EXPLORATION PROCESS

Week 1. Start simply. Pencil is a good place for everyone to start. It's the lowest maintenance, and most accessible medium. Paper and pencil and you're ready to go! It's often used for planning designs in many other mediums. Plus, it's beneficial to start in black and white.

Week 2. Working with color. Select a medium that allows you to play with color. Colored pencils, markers, pastels, are all great ways to play with color. There are many other color mediums, but for this stage select a medium that doesn't have a steep learning curve.

Week 3. Creative Crossroads. This is where your path is most likely to start branching off from the one I outline. That is 100% okay. Remember your creative goals. That is what matters. Whether you paint in watercolor, or sew, or design fabric, or something else, it is YOUR creative journey.

It may take you a few weeks to figure out when and where you want to diverge. When in doubt, follow what I suggest for as long as you need to. It is nice after the control of working in colored pencil, to try the looseness of watercolor. I'm biased because watercolor is my favorite medium. You give up a little control with watercolor. It's fun and magical to let the watercolors do their "thing." But, if watercolor really doesn't appeal to you, pick a medium that is "looser" than pencil. Explore giving up a bit of control.

Important— If you try a medium for a few days and feel like quitting because of the medium, ask yourself:

Can I make it through the week?

If the answer is no, and you are in danger of quitting altogether, switch to another medium, maybe the one from the previous week.

If the answer is yes, I suggest you stick it out. Trying new things is uncomfortable. We become comfortable over time when we keep doing them, as we start to develop systems and skills. It's worthwhile to step out of your comfort zone—to push through hard phases. Give yourself time to work out the kinks and feel comfortable again. And at the end of the week, if you say, "I don't like _____!" you learned something and you get to move on to a different medium. That is progress!

The objective is to keep you on track with regular creativity, and exploring mediums.

CREATIVE MEDIUMS

Circle the mediums you are interested in. Add any that are missing.

Pencil	Sewing
Colored Pencil	Quilting
Watercolor Painting	Knitting / Crochet
Gouache	Embroidery
Acrylic Painting	Repeating Patterns (Surface Design)
Collage	Glass Working
Pastels	Metal Smithing
Paper Cutting	Wood Working
Digital Illustration	Refinishing Furniture
Oil Painting	Airbrush Painting
Block Printing	Paint Pouring
Animation	Encaustic - Melting Wax
Photography	Clay / Pottery / Sculpture
Textile Design	Sun Printing

Change the medium for each week as you need to. Consider how mediums can build on each other, and the level of skill they require at the start. It's easier to work on "low barrier to entry" mediums in the beginning and build up to "harder" mediums later.

• Week 1 - Pencil or _____

• Week 2 - Colored Pencils, Markers, Pastels or _____

• Week 3 - Watercolor or _____

• Week 4 - Ink or _____

• Week 5 - Acrylic Paint or _____

Week 1

QUICK SKETCHES AND INSPIRATION

START DATE:

END DATE:

Let's get started!

Creative Tips

PLAN YOUR CREATIVE TIME

Things don't happen unless you plan for them to happen. Decide what day and time you'll be creative. I recommend at least 15 minutes a day plus a longer block of time at least once a week.

Time is always an issue. Look at what you spend time on and see where you can make changes. Maybe you can do the shorter activities while enjoying your morning coffee? Or wake up a little earlier? Whatever works for you. Think of ways you can take time from other areas—less Netflix or social media? Enlist your family to clean up after dinner so you can be creative. You don't need a lot of time, and if you fit in 10–15 minutes a day, you'll be inspired to fit in more.

Put it on your calendar!

DON'T WAIT

You can't wait for inspiration to strike to create. You have sit down regularly to allow ideas to come to you. I usually don't have an idea or fully-formed plan. I sit down, find a good podcast, open my sketchbook, and maybe look through what I last worked on. I might browse through recent photos I've taken, or an idea will come to me, and I'll Google something for a reference photo. The process of sitting down, setting up, and starting my routine gets my mind working. If nothing occurs to me, I'll doodle or play with color. I'll "warm up" and let an idea come to me.

CREATIVE WORKSPACE

Carve out a spot for yourself to work. Natural light is key! If you can't permanently leave your stuff set up, store it in a nearby cabinet or closet. I used to paint at the kitchen table. I kept all my supplies in a tray in a nearby closet. I could grab everything in one trip. It was easy. Now I prefer the light in the family room. I leave my paints set up at the table. All I have to do is sit down. Leaving stuff out is a visual reminder every time you walk by. The easier you make it, the easier it is to get to work.

YOU CAN BE CREATIVE ANYWHERE

Don't let not having a fancy studio space keep you from creativity. A sketchbook is portable—take it outside, to the couch, etc. I sometimes draw while watching TV. Something strikes me and I'll pause to draw it or take a picture. Often I'll sit in bed waiting for the kids to get ready for school, drinking my coffee and sketching. It's nice to have a spot, but not necessary. Look around your house for a space you could set up and store your supplies. Working with some mediums requires more of a dedicated space (oils, acrylics, a sewing machine). Be creative and carve out a space for yourself in your home.

THE WEEKLY CHECKLIST

A few weeks into My Creative Resolution I created a weekly checklist—a simple list of the types of things I wanted to do that week, with boxes for checking things off. I drew it in a corner of my sketchbook and it looked like this:

Weekly Check-list

5 Minute sketches
1. ☑
2. ☑
3. ☑

Illustration ☑

This little list kept me in check. It reminded me of what I wanted to work on each week (I can easily get distracted). It motivated me, too.

For the next six weeks (and hopefully beyond), after you read the assignments for the week, create your own checklist in a corner of your sketchbook or on your calendar. Refer to it during the week to keep you on task. Check off items when you accomplish them!

When you don't complete an item, keep going. DON'T GIVE UP. There are days I'm too busy or distracted by other things (family, work, etc.), and I don't sit down and paint— not even for five minutes. It is okay to miss a day or two, but don't allow days to become weeks. Be kind to yourself and get back to it!

ACCOUNTABILITY

Accountability can go a long way towards helping you stay on task. I started the blog for accountability. Here are some ways to hold yourself accountable:

• Use your Weekly Checklist.

• Share your intentions with family or friends and keep them updated.

• Post goals, progress, and final projects on social media.

• Ask a friend to be your accountability partner and report your progress every week. Maybe they have their own goals and you can do the same for them.

• Start your own blog.

• Check off your creative days on your calendar.

• Set a reminder on your phone. Mine goes off at noon every day and says, "Did you draw today?"

No matter what system you use to hold yourself accountable, make sure your intentions are clear and measurable, and check in at least weekly.

YOUR ACCOUNTABILITY PLAN

Write down the way(s) you plan on holding yourself accountable:

YOU ARE THE MAIN INGREDIENT

Accountability is important, and helpful. Other people or systems can help keep you in check and get you back on track. But you are the main ingredient in your creative journey. You have to make the decision to do the work, and to motivate yourself, especially when your enthusiasm wanes. I know you want regular creativity to be part of your life. You are reading this book! You can do it. I believe in you! Remember what Jeff Goins said: "You can become the person you want to be."

Week 1

QUICK SKETCHES AND INSPIRATION

Read through the entire Week 1 section before starting.

SUPPLIES FOR WEEK 1

Sketchbook – Don't buy anything that you'll feel is too nice, too "precious"—nothing that you'll be worried about ruining. You should feel free to practice and play in your sketchbook.

Pencils – Drawing pencil sets come with B pencils and H pencils. B pencils are softer; H are harder. A 6B is softer than a 2B. H pencils are great for fine lines, while Bs are great for shading. Start with a few of each.

Eraser – Kneaded erasers are the best. They remove the pencil from the paper—no pink smudges.

CREATE A WEEKLY CHECKLIST WITH THE FOLLOWING ITEMS:

• Pencil shading scale
• 7 Pencil sketches
• 1 Pencil drawing "project"
• 2 Inspiration gathering sessions

PENCIL SHADING SCALE

Use the illustration below or draw a long narrow rectangle, approximately 5.5" wide by 1" high, and divide it evenly into six sections. Leave the first box empty. Shade each box a little darker than the last. Fill the last box as much as possible so it's as dark as you can make it. This exercise illustrates how you can create darks and lights by altering the amount of pressure you apply to your pencil as well as the density of your lines.

PENCIL SKETCHES

Every day spend at least 10–15 minutes sketching any object in or around your home. Don't know what to sketch? Pick the most obvious subject. If you still need ideas, look at the Week 1 extra – What to Draw. It's important to think of these sketches as practice and play, not as a test or a final sketch that should be critiqued. Sketching is as much about seeing the object as it is about translating what you see onto the paper. Date your sketches so you can look back on your progress. As your sketches get better, you'll be motivated to continue your new creative practice.

PENCIL SKETCHING TIPS

• Start with the outline – Draw the outline of the shape. Practice by drawing the outline over and over.

• Start with shaded areas – This time create the different shaded areas, starting with the darkest area and working to the lightest. Try this approach a few times.

• Have more time? Change your perspective on the object by moving it or yourself. Notices how this changes the shape, highlights, and shaded areas.

• Practice makes progress. Sketch your subject not once but several times, studying the object as you draw. With each sketch you'll learn more, and notice more.

• As you sketch, if any new project ideas come to you, add them to your ideas list.

After practicing in your sketchbook for a few days, it's time for a drawing that you spend more time on—your project for the week. After all your loose, quick sketches, you are ready.

If you decide not to work in pencil, you can still use the steps below as a general guideline for your project.

- Pick a subject to draw—in person or from a reference photo. Beginners may find objects easier than people or landscapes.

- Study it—the shadows and highlights, the lines, the overall shape.

- Do a few small sketches as practice.

- Lightly sketch it onto your paper to plan your composition.

- Consider using a form of the grid method by dividing your reference photo into 4 sections, dividing your page into 4 sections, and transferring the content one section at a time.

- Check progress on your drawing by turning your reference photo and paper upside down.

- Fill in the shadows.

- Erase pencil areas to reveal the highlights.

- Blend areas with a tissue (or blending tool—tortillon or stump) to soften areas.

- Prop up your drawing and take a step back to get a different view.

- Come back to your drawing a day later. Stepping away and coming back to a project with fresh eyes can reveal a lot! It can even make you appreciate your progress and be less critical.

- Continue working on your drawing for a few days until you are satisfied with the results. Don't judge it too harshly.

- Celebrate finishing your first project! Sign it. You should be proud. Remember it's an accomplishment if it reveals areas to work on NEXT time. It's a learning process.

This exercise is not ONLY about practicing drawing in pencil, but about dedicating your time and attention to a longer project.

The goal is finished, NOT "perfect."

Finding Inspiration

GET OUTSIDE AND TAKE PHOTOS!

This week, go outside a few times—Take a 10-minute stroll around your yard if you have one; take a walk through your neighborhood; or visit a park, nature preserve, beach, pond, or whatever is accessible.

A large part of being creative is noticing things, opening your eyes to inspiration, "stopping and smelling the roses." I remember that first autumn after starting My Creative Resolution, I was amazed by the colors of the leaves. It was almost like I had never seen fall foliage before.

As you walk, focus on looking around, and when something strikes you as interesting take a photo. At the end of the week, look through your photos and select ones to add to your ideas list. If possible, collect interesting things—a leaf, a shell, an acorn. Start a "things to sketch" list.

WHERE TO LOOK FOR INSPIRATION

- Step outside
- Look in the refrigerator
- Everyday objects around the house
- Pause the TV and draw what you see
- Flip through a magazine
- Google a word
- Browse through the photos on your phone

THINGS TO SKETCH:

Creative Tips

USE CAUTION WHEN LOOKING AT THE WORK OF OTHERS

During the Creative Exploration process, I think it's important to keep an "inward" focus when it comes to looking at the work of other creatives. While it's great that we have access to so many creatives and their art, even the most accomplished artist can feel discouraged when they see others' work and compare it to their own. Give yourself time to get started.

For the next few weeks, before opening Instagram, ask yourself if you have created today. When you do go on social media, promise yourself that as soon as it stops being inspirational, you'll get off. Instead of looking at everyone's highlights, consider taking a deeper dive into a few artists. Learning about an artist's full story—their beginnings and struggles—can really be inspiring. I love listening to podcast interviews with other creatives. It fills me with hope that I can do it.

Most of us spend a lot of time on our devices. I definitely do. I'm on my iPad scrolling through my newsfeed, on social media, checking email, or binge watching shows. I'm absorbing content and ideas. At a certain point you have to stop taking it all in and start letting it out. Creativity allows us to let it out. Let the ideas flow out of you; get in the zone. Be a creator, not just a consumer.

FINDING AND FOLLOWING YOUR MUSE

When I started My Creative Resolution I wondered what my "thing" would be. It's possible that as you start your creative journey, you'll pick your thing and that'll be it. But for me it was a journey of experimenting and trying new things—both mediums and subjects—before I found a style that felt like me and a subject that felt like me. It's a happy time when you hit your groove. But don't expect to pluck it out of thin air. Give yourself time and space to evolve and arrive at it. And realize it may be a temporary stopping point before you continue on your journey.

There have been times when I've sat with my sketchbook open and thought, "What should I draw?" In reality, there are so many things surrounding you to choose from! Many of these things don't seem interesting at first—in fact, we hardly notice them—but they are great practice. Once you start drawing, you'll see the challenge in capturing their shapes, shadows, perspective, etc.

- Lamp
- Padded chair
- Pillow – capture all the creases and folds!
- Patterns on curtains, couch, or pillow
- Accessories
- End tables – some have such interesting bases
- The Living Room – part or all
- Kitchen or Dining Room chairs
- Ceramics – statue or teapot
- Cups
- Utensils or cooking tools – that pasta thing!
- Light fixture
- Fruit – whole or sliced
- Vegetables
- Cleaning products – like a spray bottle
- Vacuum
- The Kitchen – all or part
- Sink knobs and faucets
- Robe
- Shoes
- Handbags
- Jewelry
- Makeup
- Makeup table
- Bedroom – all or part
- Laundry – folded or messy, the basket too

- Backpacks
- Trophies
- Hats
- Sports equipment
- Stuffed animals
- Kid's or guest bedroom – all or part
- Bookcase
- Computer or laptop
- Charging area with phones
- Pile of mail
- Spice cabinet
- Pantry – inside and out
- Laundry room
- People (take photos if they won't sit still)
- Pets (take photos)
- Your neighbor's house
- Your street
- Car
- Plants
- Trees
- Flowers
- Patio or deck with furniture
- Lawn mower
- Watering can

Once your eyes open to the everyday things, you'll never again wonder for long "What should I draw?"

Take a minute to think about how Week 1 went.

What went well?

What did you struggle with?

How did you feel about working in pencil (or whatever medium you chose)?

Are there any specific techniques you'd like to practice or learn?

Did you uncover anything new you'd like to learn or explore?

How did it feel to practice creativity regularly?

What obstacles did you face this week (if any)?

Week 2

EXPLORING COLOR

START DATE:

END DATE:

Have fun!

Creative Tips

PLAY! DON'T PUT PRESSURE ON YOURSELF OR JUDGE YOUR WORK

Kids love making art—probably because they aren't that focused on the final outcome. They get to enjoy the process. Ever see a young child drawing? They finish their drawing, toss it aside, pick up a new piece of paper, and start a new one. Stressing about the final outcome can be paralyzing. Instead, enjoy the process of creating.

THERE'S ALWAYS THE NEXT PROJECT

Stop yourself before you ruin a project by trying too hard to make it "perfect" and overworking it. At a certain point a drawing, painting, or other creative project, "is what it is" and only small tweaks are possible. Finish your project, and take note of the challenges you had. Consider researching how others handle this challenge to prepare yourself for next time. A project is a moment in time in your journey.

STARTING IS THE HARDEST PART

Starting is the hardest part, whether it's a new project or picking up an unfinished one. When you sit down and get to work, a plan will begin to take shape. You'll be back in the groove in no time.

KEEP THE MOMENTUM GOING

A gap of more than a few days can feel like starting over. You forget where you left off. Sometimes I have to force myself to sit down and pick up an old project. Keep the momentum going—don't let too much time pass when you are in a project.

DON'T BE IMPATIENT

My daughter was working on a project for her high school art class. She said, "This is the first time I was able to create what was in my head." I said, "Do you know why? Because you tried it over and over." I remember being impatient—thinking I should get it right the first time. When I didn't, I assumed it was a problem with me – that I didn't have enough talent. Now when I draw an object in my sketchbook, I draw it over and over. I don't expect to get it right the first time.

Week 2

EXPLORING COLOR

Read through the entire Week 2 section before starting.

SUPPLIES FOR WEEK 2

Colored Pencils – There are beautiful colored pencil sets on the market—I have sets of both Derwent and Prismacolors—but it isn't necessary to spend a lot of money when you are starting out and trying a medium. I originally used a Crayola set left over from my kids' school supplies. With that Crayola set, I created a few drawings that are still special to me. Use what you have; you can always upgrade later.

Alternatives: Markers or Pastels (pencils or sticks)

CREATE A WEEKLY CHECKLIST WITH THE FOLLOWING ITEMS:

- 7 Colored pencil sketches
- Create a color wheel
- 1 Colored pencil drawing "project"
- 2 Inspiration gathering sessions

Continue sketching every day for at least 10–15 minutes, but this week work with colored pencils. In addition to thinking about darks and lights, now color comes into play. For the first few sketches, use only one to two colors. Play around with "mixing" colors by adding colors on top of each other.

COLORED PENCIL TIPS

- You can color with the point of the tip or the side of the tip, for different coverage.

- You'll never have an unlimited number of colors, but you can "mix" colors by adding a layer of one color on top of another color (use the side of the tip, not the point). Use a white pencil to further blend the colors.

- Experiment with creating shadows by mixing a color with its complement.

- Colored pencil doesn't erase as easily as regular pencil.

- Instead of adding white, use less pressure to allow more of the white of the paper to show through.

INSPIRATION

Continue soaking in inspiration, writing new ideas down on your idea list, and adding to your "things to sketch" list.

THE COLOR WHEEL

There are three primary colors: red, blue, and yellow. The colors you create by mixing two primary colors are called secondary colors: green, orange, and violet. Colors across the color wheel from each other are called complementary colors. Adding a complement to a color will desaturate a color, making it less bright.

A hue is the pure pigment of a color. Add white to a color to create a tint. The more white you add, the lighter it gets. Add black to a color to create a shade. The more black you add, the darker it gets.

I was very surprised in an painting class when the teacher recommended we didn't buy every color we needed, but instead mixed our colors. He also suggested that when adding a color to a painting—like orange, for example—we mix a bit of the complementary color, to tone it down, and make it look more natural.

Imagine that when you paint using the colors straight from the tubes, your colors (hues) would be bright—almost circus-like. But if the colors are mixed, and complements used to tone down colors, your colors would look more natural. What you choose to do with color all depends on your personal preference and the look you are trying to achieve.

Use the template below to Create Your Own Color Wheel

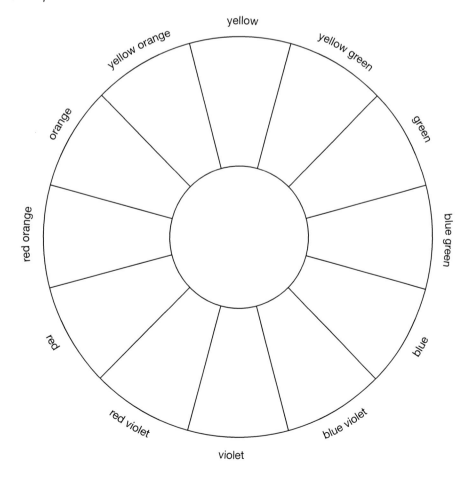

WEEK 2 PROJECT – COLOR DRAWING

If you decide not to work in colored pencil, you can still use the steps below as a general guideline for your project.

- Pick a subject to draw—in person or from a reference photo. I find people or landscapes more challenging when using colored pencil.

- Study it—the shadows and highlights, the lines, the overall shape.

- Identify the colors and test your colored pencils to decide which pencils you'll use. Test "mixes" of the colors that you'll need to create, including shadows.

- Do a few small sketches as practice.

- Using regular pencil, lightly sketch your subject onto your paper to plan your composition.

- Consider using a form of the grid method by dividing your reference photo into 4 sections, dividing your page into 4 sections, and transferring the content one section at a time.

- Achieve highlights by leaving areas blank or by removing color with an eraser. Remember colored pencil is harder to completely erase.

- Color in the areas, adding the lighter colors first then working up to the darker colors.

- Fill in the shadows by adding another color, like the complement, on top of a color, or add black. Test this first.

- Use a white pencil to blend areas (as desired).

- Check your progress on your drawing by turning your reference photo and sketchbook or paper upside down.

- Prop up your drawing and take a step back to get a different view.

- Come back to your drawing a day later.

- Continue working on your drawing for a few days until you are satisfied with the results.

- Celebrate finishing. Sign your drawing.

- Make a few notes on the most successful aspects of your project, and areas you'd like to work on in the next project.

Creative Tips

NEGATIVITY SQUASHES CREATIVITY

The other day I woke up and thought:
- Why am I doing this?
- This is a waste of time.
- No one will like this.
- I'm no good at this.

I don't know why it all hit me that morning, but I do know that for me feeling positive and feeling negative can be like a roller coaster ride. Sometimes I'm feeling great; I'm on fire with my projects, and then—BAM—the bottom drops out. I worry about all of the above. Not surprisingly, when I'm feeling like this I'm unmotivated and unproductive, and my creativity suffers.

On that morning, I tried something different. I wrote down each of these negative thoughts and challenged myself to turn them into positives.

FROM NEGATIVE TO POSITIVE:

- Why am I doing this? Because I've wanted to do this forever.
- This is a waste of time. Maybe, but I'll never know until I try.
- No one will like this. Maybe not, but the process of doing it makes me happy.
- I'm no good at this. I'm better than I was before I started.

Chances are you will experience a lack of confidence somewhere along your creative journey. If you do, turn your negative thoughts into positive statements. Then, instead of rethinking your negative thoughts, reread your positive statements a few times.

Mine read:
- I've wanted to do this forever.
- I'll never know until I try.
- The process of doing it makes me happy.
- I'm better than I was before I started.

Reading those statements helped turn things around for me! Past experience has taught me to stick with it through those hard times, because an upswing is just around the bend, and many times you're just about to reach a higher place than you've been before. Don't give up on your creativity.

WEEK 2 RECAP

Take a minute to think about how Week 2 went.

What went well?

What did you struggle with?

How did you feel about working in colored pencil (or whatever medium you chose)?

Are there any specific techniques you'd like to practice or learn?

Did you uncover anything new you'd like to learn or explore?

How did it feel to practice creativity regularly?

What obstacles did you face this week (if any)?

Week 3

WORKING LOOSE

START DATE:

END DATE:

Give up control and play loose!

Creative Tips

ENJOY YOUR CREATIVE TIME

I think of my creative time like morning meditation, especially on the days when I only have 15 minutes or so before I rush off to work or to other things. It starts the day on the right foot.

Focus on enjoying the quiet time—on working, learning, exploring, and growing. Don't focus on the end result. The end result will take care of itself.

DO SOMETHING OVER AND OVER

Don't waste time criticizing your work. Instead, try again. Draw or paint something over and over, especially when doing quick sketches. I guarantee you will see progress. It's worth the effort. Over time, you'll see your subject more clearly and your skills will develop.

BUILDING UP THE LAYERS

Creating a drawing or painting, or another type of work, is like bringing a camera into focus. You start with "blurry" layers, and add more layers—more detail and finer lines or brush strokes—until the drawing or painting comes into focus. You're building up the layers. It's an amazing process to be part of—adding each layer until the finished piece clicks into focus.

KEEP A JOURNAL

I write in a notebook every morning. It's not quite a diary, but I do include a little bit about my thoughts and feelings. It's more of a daily check in on my creative practice. I include all the areas I want to work on and where I am with them. I write down what I'm planning on creating that day. The notebook is important because it allows me to unload my thoughts, and creative struggles, and I can look back to see where I was and what I was focusing on. There is nothing like revisiting where you came from, to recognize your growth and progress.

BREAK FROM YOUR ROUTINE

We all get into ruts, doing the same thing every day. Change things up! Eat lunch in a new spot, or perhaps bring lunch and eat it outside. Go to a new place for your walk or run. Wake up early and spend time being creative. Drive to work a different way. A change of scenery helps you see what's around you. I'm a big fan of sitting outside. There is something almost meditative about listening to the birds, and the wind rustling the leaves.

Week 3

WORKING LOOSE

Read through the entire Week 3 section before starting.

SUPPLIES FOR WEEK 3

Paint – Use what you have on hand, or start with student grade paints. I prefer the paint in tubes instead of cakes. If you love watercolor, you can invest in artist grade paint later.

Palette – A palette isn't a necessity, but for convenience I use one. I keep a little bit, from each paint tube in the separate wells. I reactivate the dry paint with a little water.

Mixing tray – Buy one, or use the top of a plastic egg carton, take out container, or ceramic dish. Having a place to mix colors or dilute paint keeps your palette colors pure.

Paper towel – A piece of paper towel to blot (dry) your brush on.

Paper – Use watercolor paper. It is designed to have the perfect amount of absorption, and can withstand a good amount before the paper breaks down. I also use a Multimedia sketchbook for quick paintings and illustrations.

Painter's Tape & Cardboard – If you plan on covering most of the paper with paint, it is important to tape down the paper to a larger piece of cardboard to prevent the paper from buckling.

Brushes – A few round brushes in different sizes

Water – A container of water for diluting your paint and cleaning your brushes.

CREATE A WEEKLY CHECKLIST WITH THE FOLLOWING ITEMS:

• Watercolor tints
• 7 watercolor sketches
• Create a watercolor color wheel
• 1 watercolor painting "project"
• 1-2 Inspiration gathering sessions

WATERCOLOR TINTS

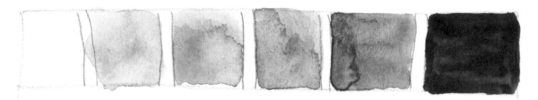

On multimedia sketchbook paper or watercolor paper, draw a long narrow rectangle and divide it into 6 boxes. Add an extra line next to your dividing lines so there is a gap between each box. (We don't want the paint in the boxes to run into each other.) Leave the first box empty (white). Wet your brush and dip it into any color of paint. On a mixing tray (or plastic egg carton) brush your paintbrush back and forth to make sure there is enough water that the brush is painting smoothly. Paint the last box with a brush saturated with paint, so it's as dark as possible. Dip your brush in water and blot once on the paper towel to absorb excess water and paint the box next to the darkest box. Dip your brush in water and blot once on the paper towel (to absorb excess water) and paint the box next to the previous one. Repeat until all the boxes are painted except the empty (white) one.

The difference between this scale and the pencil one is that you are creating tints of a color not by the amount of pressure you apply but by the amount of water you add to your paint.

WATERCOLOR SKETCHES

Continue "sketching" every day for at least 10-15 minutes, but this week create your "sketches" with watercolor. Painting with watercolor is all about how wet your brush and your paper are. Test out the different ways to paint with watercolor:

- Dry brush on dry paper
- Wet brush on dry paper
- Wet brush on wet paper – Wet an area of your paper. Notice when your brush touches the wet area the paint easily spreads.

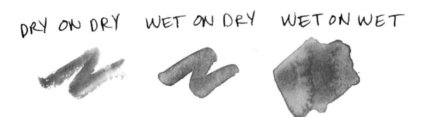

WATERCOLOR TIPS

• Bleed - Wet paint bleeds into other wet areas. If you have a wet painted area and you paint another color next to it, when they touch, the paints will run into each other. This can create beautiful effects. When you don't want this to happen, let areas dry before adding wet paint near them.

• Blooms - The same thing will happen if you have a painted area and you touch it with a wet brush. The water will bleed into the area and create a bloom.

• Creating a watercolor painting is all about building up the layers. Most often the beginning layers are painted wet and loose, with diluted paint. Let layers dry before adding paint on top (unless you want the paint to bleed into the previous layer). Subsequent layers are painted with a drier brush to achieve finer details.

INSPIRATION

Continue soaking in inspiration, writing new ideas down on your idea list, and adding to your "things to sketch" list.

WATERCOLOR COLOR WHEEL

Create a watercolor color wheel on watercolor or multimedia paper. Draw a circle with a smaller circle inside. Divide the circle into quarters, then divide each quarter into thirds. Use the color wheel on below as a guide, but worker larger.

First fill in the primary colors – red, blue, and yellow. Next mix the primary colors to create the secondary colors. Allow areas to dry before painting next to them – to avoid the paint bleeding. Compare the colors you mixed, to other tube colors you may have.

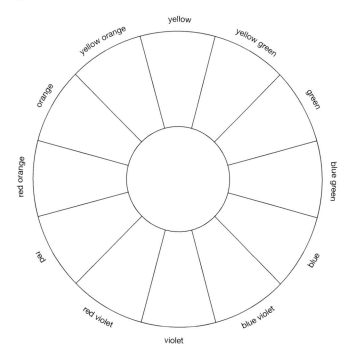

WEEK 3 PROJECT - WATERCOLOR PAINTING

If you decide not to work in watercolor, you can still use the steps below as a general guideline for your project.

- Pick a reference photo of a landscape or seascape.

- Study it.

- Identify the blocks of colors and test your paints to decide which you'll use. Test "mixes" of the colors that you'll need to create.

- Do a few small watercolor sketches as practice.

- Tape watercolor paper to a larger board with painter's tape.

- Decide if you want to use a regular pencil, to lightly sketch your subject onto your paper to plan your composition, or go straight to paint.

- Start wet – Add the first layer of your painting. The first layer is painted with a wet brush (often onto a wet page), which allows the colors to bleed into each other. The colors are often light because they are diluted with water.

- Let the first layer dry (unless you want the next layer to bleed into the first layer).

- Work with a drier brush with each layer, and a brush more saturated with paint – less water. (Blot your brush on the paper towel to absorb water as needed.)

- Continue adding layers and finer details as needed, until you are satisfied with the results. I usually work over a period of days to allow for drying time between layers.

- Prop up your drawing and take a step back to get a different view. Add details as needed.

- Sign your painting and celebrate!

- Make note of successful areas, and any areas to work on for next time.

Creative Obstacles

TIME

We all lead busy lives, but if creativity is a priority you can find time for it. Wake up a few minutes early, watch less TV, or practice creativity while you watch TV. Give up time spent on other things or incorporate creativity with those things. Sometimes I sketch while having my morning coffee and waiting to drive the kids to school.

LACK OF SKILL

There's nothing worse than being in the middle of a project and feeling like you lack the skills to finish. I recommend pausing your project and using the online resources that are available. A quick YouTube video, followed by a practice session, can get you back on track. After your project, consider if you want to find resources to help you improve specific skills. There are so many ways to be creative and a wealth of information online! Later on, consider taking an online or in-person class or workshop in addition to—not in place of—your daily creative practice.

CONFIDENCE

You may think it's not worth it to spend your time on creativity because only the talented should spend time being creative. Should only yogis bother doing yoga, or Olympic runners spend time running? There are benefits to creativity at every level!

MOTIVATION

Wanting to be creative and actually doing it are not the same thing. Find ways to motivate yourself. Work on things that excite you. Participate in challenges. Create schedules and deadlines. Break down bigger projects into small tasks with a due date for each task.

PROCRASTINATION

I can spend hours in my notebook, planning the creative projects I'm going to do, or outlining the next steps of my current projects. The longer I procrastinate, the harder it is to break out of the planning mode and actually create. I take advantage of breaks in my day to change gears and stop procrastinating. Sometimes, I set a timer when I sit down to procrastinate, setting an end time for the procrastination.

DISTRACTION

There is so much distracting us. Set a daily reminder on your phone. "Were you creative today?" My reminder goes off at noon and reads, "Did you draw today?" Often when I see it, I literally say, "Oh yeah—I want to do that."

WEEK 3 RECAP

Take a minute to think about Week 3.

What went well?

What did you struggle with?

How did you feel about working in watercolor (or whatever medium you chose)?

Are there any specific techniques you'd like to practice or learn?

Did you uncover anything new you'd like to learn or explore?

How did it feel to practice creativity regularly?

What obstacles did you face this week (if any)?

Week 4

PERMANENT MARKS

START DATE:

END DATE:

Learn to improvise when you can't erase!

Creative Tips

DO A STUDY

Before tackling a project, try doing a study. This could include pencil sketches, exploring color mixes, playing with different compositions. I have seen studies of many of the most famous paintings. The time spent up front will improve your final piece.

TAKE NOTES

Keep track of details about your projects—which reference photo was used, what colors or marker thickness you chose, and anything else you may want to refer back to in the future. These notes are very helpful when you forget where a photo is saved, which ink pen or paint you used, or which colors you mixed. Take photos of your progress.

CREATIVITY TAKES COURAGE

Working in ink is scary—you can't erase it. Every line is permanent. Being creative is scary, too. You are putting a piece of you onto the page. Whether you share it online or just with those close to you, it's a vulnerable position. You open yourself up to feedback, whether you ask for it or not.

When I started posting my projects online, I was anonymous. I felt protected if no one knew who I was. But over time, I grew more confident in sharing what I was doing, and I revealed who I was. I shared my creative struggles and successes. One comment brought me to tears. The reader essentially told me to stop whining and criticizing my own work. After the initial sting of the comment subsided, I realized she had a point. I was pointing out all the things wrong with the work I posted. I was so afraid of putting myself out there, but in reality I was my harshest critic! After that, I was kinder to myself. Now I might make note of areas I want to improve for next time, but I post what I make with pride.

IT ONLY MATTERS WHAT YOU THINK

Unless you need people to buy your work to feed yourself and your family, does it matter if no one like your work? We all like positive reinforcement—even if it's just from our family. If you create something and feel joy with the process and result, it doesn't matter what others think. It only matters what you think.

If I waited for someone say, "Hey you are pretty creative, why don't you spend time drawing and painting?" It never would have happened. The drive to create has to come from within, as does recognizing your progress and growth as you spend time on your craft. Don't be your harshest critic—there are plenty of those around. Be kind to yourself, and cheer yourself on.

Week 4

PERMANENT MARKS

Read through the entire Week 4 section before starting.

SUPPLIES FOR WEEK 4

Ink Pens—thick or thin markers, pens, or gel pens—whatever you have on hand is fine. I've used Sharpies and have bought tons of fine-tipped markers, but my current love is a simple gel pen, a Uniball Signo—it's so smooth! It is NOT waterproof, so I try to use caution when adding watercolors after the ink because the ink will bleed.

CREATE A WEEKLY CHECKLIST WITH THE FOLLOWING ITEMS:

- 7 ink sketches
- 1 ink drawing project – optional addition of color
- 1-2 Inspiration gathering sessions

INK SKETCHES

Sketch every day for at least 10–15 minutes, but this week, work with an ink pen or marker. For the first few days, work exclusively in ink.

I was originally afraid of ink—every line is permanent. I thought the lines needed to be perfect. Then because I can't draw a "perfect" line, I drew many lines to compensate, and surprisingly my style emerged. I realized that imperfect, wonky hand-drawn lines, are much more interesting than the ones we can create with a ruler.

INK SKETCHING TIPS

- Start by drawing the outline of your object, then add the details and shadows.

- Consider subjects with a lot of obvious lines and details, like animals, feathers, baskets, etc.

- Experiment with different ways to add darks and shadows, including parallel lines, crossed lines (hatching), or dots (stippling).

- Consider adding color to your ink sketches with pencil, marker, or watercolor. Try starting with color first, then the ink details. Next reverse this by drawing the object in ink, then filling in the color. Use a waterproof ink if adding paint after the ink.

WEEK 4 PROJECT – INK DRAWING

Your choice—work 100% in ink or add color with colored pencil, marker, or watercolor. If adding color, decide if you will start with color or start with ink. Remember to use waterproof ink if adding paint after the ink.

If you decide not to work in ink this week, you can still use the steps below as a general guideline for your project.

• Pick a reference photo of an object.

• Study it.

• Identify the darks and lights.

• Do a few small sketches as practice using different ink techniques—parallel lines, hatching, dots, etc.

• Decide if you want to use a regular pencil to lightly sketch your subject onto your paper to plan your composition.

• Decide if you are adding color in the beginning. If so, add the blocks of color.

• Draw the overall outline of your subject. Be careful not to smudge areas that aren't yet dry by leaning on them. Consider placing a paper towel on your drawing to lean on and prevent smudging.

• Begin adding more details. Some people work section by section, completing an area fully before moving on. Some people—like me—work in layers, adding a more detailed layer each time, working on the whole drawing.

• Continue adding finer details as needed.

• If adding color at the end, fill in the color now.

• Add additional ink details as needed. (Make sure any paint is completely dry.)

• Prop up your drawing and take a step back to get a different view. Add details as needed.

• Sign your drawing and celebrate!

• Make note of any "struggles" to work on next time.

Phases of a Creative Project

THE SPARK OF AN IDEA. "THIS IS GENIUS!"

THE START. "THIS IS GOING TO BE AWESOME!"

FIRST OBSTACLE. "THIS STINKS."

OVERCOMING THE FIRST OBSTACLE. "THIS IS OKAY."

THE NEXT OBSTACLE. "THIS WON'T WORK."

OVERCOMING THE NEXT OBSTACLE. "THIS MIGHT WORK."

REPEAT ABOVE FOR ADDITIONAL OBSTACLES.

FINALIZING THE PROJECT. "THIS WORKS!"

FINISHED. "I MADE THIS!" "WHAT SHOULD I MAKE NEXT?"

Take a minute to think about Week 4.

What went well?

What did you struggle with?

How did you feel about working in ink (or whatever medium you chose)?

Are there any specific techniques you'd like to practice or learn?

Did you uncover anything new you'd like to learn or explore?

How did it feel to practice creativity regularly?

What obstacles did you face this week (if any)?

Week 5

EXPLORING A NEW MEDIUM:
ACRYLICS

OR

START DATE:

END DATE:

Don't be afraid to be a beginner.

Creative Tips

EVERY CREATIVE SESSION IS VALUABLE

Every time you sit down to paint/draw/create—whether or not you are happy with the results—you learn something. You learn what subjects interest you, what areas you are struggling with, what mediums you enjoy. While you're working, ideas for new projects will appear, some related to what's in front of you, and some seemingly unrelated.

DEVELOPING YOUR STYLE

Developing a style takes time and practice. A realistically rendered artwork is amazing: Is it a photo? A painting? Pastel? But just as appealing is a doodle with wobbly lines and blocks of color. With the doodle, we admire the style and interpretation of the subject. Imperfection has style. Do it your way—the more you do it in your style, the more unique it is.

STARTING SMALL

Starting small, literally small, is a less intimidating way to try a new medium. With a smaller piece of paper or smaller canvas, there's less to fill. You can also limit your choices, by starting with only a few tubes of paint, or a handful of markers, fabrics, or threads. Limiting your choices can make a new medium seem less overwhelming. You can always go bigger next time.

Week 5

EXPLORING A NEW MEDIUM

Read through the entire Week 5 section before starting.

SUPPLIES FOR WEEK 5

Acrylic Paints – Start simply with tubes of blue, red, yellow, black, and white and mix any colors you need from there. You can invest in more paint if you choose to continue with acrylics.

Brushes – a few of varying sizes, flat and round

Canvas – a canvas pad and 2 small canvases approximately 12" x 16"

Palette – plastic palette or palette pad

Rag and container of water

CREATE A WEEKLY CHECKLIST WITH THE FOLLOWING ITEMS:

- 7 acrylic sketches
- 1 acrylic canvas painting "project"
- 1-2 Inspiration gathering sessions

ACRYLIC SKETCHES

Continue "sketching" every day for at least 10–15 minutes, creating your "sketches" with acrylics on your canvas pad. Get a feel for how different acrylics are to watercolors.

ACRYLIC TIPS

- Use a damp brush, but not too much water.

- Experiment with different sized brushes and flat and round brushes.

- Lighten colors by mixing with white (not water).

- Blend the colors next to each other for a more natural look. This is best achieved when the paint is wet.

- Add highlights by adding white paint (or lighter paint) to your brush and blending it with the wet paint on the canvas.

- It's easier to work when the paint on the canvas is wet and you have your colors mixed and ready.

- Mix colors with their complement to tone down the colors for a more natural look.

WEEK 5 PROJECT — ACRYLIC CANVAS PAINTING

Starting small—literally small—is less intimidating.

If you decide not to work in acrylics, you can still use the steps below as a general guideline for your project.

- Pick a reference photo of a landscape or seascape.

- Study it.

- Identify the blocks of colors and test your paints to decide which you'll use. Test "mixes" of the colors that you'll need to create.

- Do a few acrylic sketches as practice.

- Consider doing an underpainting—painting the canvas a color instead of starting with a white canvas.

- Using a neutral paint color and a thin brush, lightly sketch your subject onto your canvas to plan your composition.

- Add the first layer of your painting, blending colors as desired.

- Continue adding layers with finer details.

- Prop up your painting and take a step back to get a different view.

- Come back to your painting a day later with a fresh eye. Continue adding detail until you are satisfied with the results.

- Sign your painting and celebrate!

- Make note of any areas to work on for next time.

Take a minute to think about Week 5.

What went well?

What did you struggle with?

How did you feel about working in acrylics (or whatever medium you chose)?

Are there any specific techniques you'd like to practice or learn?

Did you uncover anything new you'd like to learn or explore?

How did it feel to practice creativity regularly?

What obstacles did you face this week (if any)?

Week 6 & Beyond

CREATIVE CHOICES

START DATE:

END DATE:

Embrace the freedom to choose!

Creative Tips

ALLOW THINGS TO UNFOLD

No matter how much planning you do up front, you never really know what the final product will be, until you work through it. Each project is a process of experimenting, learning, and adjusting as you go. Don't overthink it! Dive in and get started.

PUSH YOURSELF OUT OF YOUR COMFORT ZONE

For a while I worked with 8" x 8" watercolor paper. Then I accidentally ordered 12" x 12" paper. At first I was upset; then I decided to give it a try. Once I tried the larger size, I realized I had outgrown the smaller size. Don't wait for an accident to shake things up. Think of ways to push yourself to grow.

VISIT AN ART STORE

It's so easy and convenient to order art supplies online, but an outing to an art store can really inspire and motivate you! I love walking the colorful aisles. It can be intimidating, but the sales people have so much knowledge—ask them questions! Spending money on new art supplies can motivate you. I feel guilty if I don't put them to use!

KEEP YOUR WORK AND LOOK THROUGH IT OCCASIONALLY

Looking through your past work allows you to see how far you've come and how much your skills have improved. It's interesting to see what subjects captivated you in the past and how your interests have changed. Revisiting old projects may spark ideas for new ones. You can look at pieces with the perspective of time, and not be as critical as you were initially.

SPEND TIME WITH OTHER CREATIVES

Regardless of the medium they work in, other creatives can relate to the struggles of the creative process. Speaking aloud your ideas sometimes helps you figure things out better than if you kept it inside. Often someone else can see things more clearly.

I'm lucky to have two friends that I have creative chats with about the projects we are working on. If you don't have anyone local, try connecting with creatives online. I've developed several online relationships. Some are with people who knew me when I started, have watched my progress, and continue to cheer me on. Some are with beginners, who ask for advice and I get to be the cheerleader. Some are with creatives with interests similar to mine. We get to trade our tips and tricks.

MULTIPLE PROJECTS

I like having a few different projects going on at once. With watercolor it's especially useful, because you need to allow time for the paint to dry. I'll add a layer and then grab another painting to work on. I also like to have other types of projects, including playing in my sketchbook, or designing a fabric print. I think it's good to exercise different creative muscles to prevent boredom and stagnation.

KEEP TRACK OF YOUR PROJECTS

I can be all in on a project one week and the next week forget it exists. In the past, this contributed to not finishing projects. Nowadays I keep better track of my projects and almost daily I write status updates in my notebook. This serves as a reminder and gives me a place to break down projects into smaller tasks, so I know what needs to be done next.

KEEP ROLLING

If you get into a groove working on one aspect of your creativity and you're on a roll— keep rolling. Working on one thing is more effective than constantly switching gears. This is especially true with mediums that require a lot of set up – like acrylics, or oils. Once I'm set up, have paints mixed, and my mind is in the acrylic mode, I try to make the most of that time. I know that despite my best intentions, it will be a while before I get back into it again, and when I do it can feel like starting over.

Week 6 & Beyond

CREATIVE CHOICES

Read through the entire Week 6 section before starting.

PICK A MEDIUM TO EXPLORE

Decide if you want to continue learning one or more of the mediums you've worked in,

or

If you are looking to try something new, refer again to the list of mediums. Select a few mediums you'd like to try. Label them in the order you want to try them. The longer you work in a medium the more you'll learn techniques, get comfortable with the tools, and develop your own style. Trying a lot of things is fun, but you don't progress with any one thing when your time is divided trying new things. At a certain point you might want to make the decision to focus.

SUPPLIES FOR WEEK 6

As needed based on the selected medium.

CREATE A WEEKLY CHECKLIST WITH THE FOLLOWING ITEMS:

- 7 sketches (or the equivalent) in the medium of your choice
- Complete the Creative Ideas Worksheet
- 1 "project" of your choice
- 1-2 Inspiration gathering sessions

SKETCHES

Continue "sketching" every day for at least 10–15 minutes, in the medium of your choice. The sketches can be related to your project, a way to try out a new medium, or just a regular warm up creative exercise. I use the term sketching very loosely. In this context it means a short creative practice or warm up session. It could mean embroidery stitches on a small piece of fabric.

CREATIVE IDEAS WORKSHEET

It's time to read through the list of ideas you've created. Consider your original overall creative goal. What projects would bring you closer to this? Edit your list by transferring what is still of interest to you to the Creative Ideas Worksheet on the following page. Follow the worksheet process to gain focus on this week's project and projects for upcoming weeks.

Creative Ideas Worksheet

Brain dump all your ideas onto the list. Prioritize the ideas with an A, B, or C rating. Number the A's in priority order. Re-write the A's in order. Using the lines underneath each numbered A, break down the A's into each project's next few steps. Take these steps and write a to-do list.

CREATIVE IDEAS:

Assign priority Assign priority to the A's

A, B, or C ? # the A's

Write the A's below in order. Leave lines underneath.
Write the next step tasks on the lines under each A idea.

PRIORITY IDEAS/THE A'S:

Transfer the first task from each A idea below. If you only have a few A project ideas, transfer two tasks from each. Check off each to do list item as you complete it.

A1 ..

A2 ..

A3 ..

A4 ..

A5 ..

A6 ..

A7 ..

A8 ..

WEEK 6 – PROJECT OF YOUR CHOICE

This is a self-directed project. You choose! Not sure where to start?

- Pick a medium.

- Pick a subject and find a reference photo or work in person.

- Create practice "sketches."

- Select paper, canvas or other material in the desired size.

- Prepare paper, canvas or whatever is appropriate for your medium.

- Begin with light marks to plan your composition.

- Paint, draw, stitch, sew, the first "layer."

- Fill in blocks of color as desired.

- Continue building up the layers and adding details.

- Prop up and view from different angles.

- Come back to it in a day.

- Add more details as needed.

- Done? Sign and celebrate!

- Think about what you learned, and what challenges you faced.

- Start planning the next project.

WEEK 6 RECAP

Take a minute to think about Week 6.

What went well?

What did you struggle with?

How did you feel about working in the medium you chose?

Are there any specific techniques you'd like to practice or learn?

Did you uncover anything new you'd like to learn or explore?

How did it feel to practice creativity regularly?

What obstacles did you face this week (if any)?

What do you want to work on next?

If needed refer to your Creative Ideas Worksheet for your next project or task. Continue with regular sketching and a project that takes more time. Need some ideas? Refer to the creative exercises on page 59.

Creative Tips

CHALLENGE YOURSELF

Whether you join an existing challenge or create your own, a challenge is a great creative motivator! With each challenge I've participated in, I've felt inspired, improved my skills, and connected with other creatives. Draw or paint daily within a theme, or buy new supplies and work in a new medium for a month. Injecting a new twist on your creative practice will expand you in more ways than one.

TAKE CARE OF YOUR WORK SPACE AND MATERIALS

Often we want to jump into the fun creative stuff, but it's important to keep your space and materials organized to keep your creativity flowing smoothly. Organize your supplies from time to time, replace supplies as needed, improve your setup. Straighten up your area. Clean your brushes or other tools. The goal is to make it as easy as possible to work and feel inspired.

YOUR CREATIVE PROCESS AND ROUTINE

If you sit down to do something almost every single day, a process will emerge. The process could include:

- How you set up your materials—For me, I keep my brushes to the right, a paper towel between the painting and the mixing palette, and water at the end of the paper towel.

- What you start with—Sometimes I fiddle with a painting in progress. Other times I play in my sketchbook, or I begin with taping down paper for a new painting.

- What you do while you work—Will you listen to music, a podcast, or nothing?

- The time of day you like to work. What snacks or drinks you keep on hand.

Your process will unfold the more time you spend working in a medium. You'll find what works for you. The routine you develop helps get you mentally ready for creativity. When I'm taping down watercolor paper, it's almost meditative, I'm following steps I've done many times before. The first couple of times with a new medium, you may feel out of sorts, unorganized. You'll go to wash your brush or grab new thread and it may feel awkward. Unconsciously you'll adjust and improve your process.

Bonus: 26 Creative Exercises

The following exercises will allow you to explore different mediums

- **Drawing:** Take an everyday object and draw the outline of it over and over, on a single sheet of paper. Study the object as you draw it again, and again. Don't be afraid to overlap the outlines – it creates an interesting design!

- **Surface Design:** Take a drawing from your sketchbook—or create one—that is less than 3" square. Photocopy it to create enough squares to fill the letter size in the copier. Cut out the squares and lay them next to each other. Photocopy. You created a repeating pattern! You can also use Photoshop or other photo editing software and a scanner to create patterns.

- **Painting:** Completely cover a canvas in a bright paint color. Then create a painting, leaving the bright underpainting where you would paint highlights.

- **Block Printing:** Doodle a page of designs using a thick marker. Pick your favorite and carve the reverse of it into a sliced potato (or a linoleum block if you have it). Dip the potato or block into paint and stamp onto paper. Try different arrangements. Create another block and use the two to create different patterns.

- **Colored Paper:** Instead of working on white paper, start with a sheet of colored paper. Create a drawing using the medium of your choice—colored pencils, pastels, markers, ink pen. Notice the difference the colored paper makes in the overall look of the piece. You can also try drawing on a dark paper with a white gel pen for a reverse effect.

- **Kits** can be a great way to try mediums because all the supplies and instructions are included. Find a kit in a medium you're dying to try. I tried embroidery. If you find you love the medium, consider doing another project with your own design.

- **Collage:** Take a stack of magazines and cut them up, creating small pieces in different colors. Sort the colors as you go. Pick a reference photo and draw the outline of your subject onto card stock. "Color" your drawing by gluing the colored magazine pieces.

- **Wood:** Find a piece of discarded wood furniture, or a scrap piece of wood. Sand and paint it. Sand again to distress the piece. Consider using a stencil to add lettering or other details.

- **Jewelry:** Pick out beads, wire, and jewelry finishing pieces at a craft store and create your own unique piece.

- **Inspiration:** Look on Pinterest for a project or creative piece that catches your eye, or that you already pinned but never tried, and create it!

- **Inspiration:** Look in your refrigerator for inspiration. Cut up apples, peel oranges, cucumbers, tomatoes, etc. Create them in the medium of your choice.

- **Watercolor:** Fully wet a piece of watercolor paper with a brush. Add paint to it. Continue adding more colors allowing them to bleed into one another. Splatter paint by flicking your paintbrush. Allow your painting to dry. Consider using it as a background for an ink drawing.

- **Photography:** Choose an inspiring location or subject. Photograph it from different angles, play with composition, light, etc. Choose the best photos and blow them up.

- **Answer this:** When I was a kid I loved to make _____. Make that!

- **Recycled art:** Grab stuff from your recycle bin. Make something with it.

- **Themes:** Pick a theme or subject and create within that theme for a week or more. After a few days you may think you've run out of ideas and hit a plateau, but the best ideas are yet to come—keep going!

- **Learn:** Take a workshop or class in something you've always wanted to learn.

- **Computer art:** Use the computer to be creative: edit and stylize your photos, draw with a stylus pen, or create a collage from different photos.

- **Lettering:** Doodle with a pen or marker like you did in your notebook when you were young. Write your name or a quote. Try a thin paintbrush, a calligraphy pen with a nib and ink, or special markers like Tombows.

- **Dioramas:** Remember the shoebox diorama science projects you made in school? Create a one! Select a small box. Line the inside with paper. Place things in the foreground, such as plastic figures or cutouts.

- **Nature:** Find leaves and other interesting things, dip them in paint, and press onto paper.

- **Embroidery:** Draw with a needle and thread by sewing onto fabric. Start with something simple like the outline of a flower, tree, or your initial. You can draw it first lightly with pencil and stitch over the pencil. If you have an embroidery hoop, use it to pull the fabric tight while you work.

- **Encaustic painting:** Melt leftover crayons and use the wax to create a painting.

- **Pottery:** Visit a paint-your-own-pottery place and paint pottery.

- **Paper cutting:** Take a sturdy piece of paper and lightly sketch a drawing with clearly defined positive and negative shapes. Using an Exacto blade, cut out the negative (or positive—but not both) areas. Lay your finished piece on top of a contrasting piece of paper.

- **Sculpture:** Play with air dry clay. Mold it into something.

Creative Permission

GIVE YOURSELF PERMISSION

Several years ago I was reading an article about an artist. As I read with admiration how she finished art school and was now dedicating her time to creating art, I wondered, "Who gave her permission to be an artist? Her parents? Her boyfriend? Her teachers?"

Some time later—I don't know if it took me minutes or weeks—I realized SHE gave HERSELF permission.

We cannot wait for someone else to tell us it's okay to spend time being creative. We have to give ourselves permission.

I waited a long time to pursue my creative passions because I didn't believe in myself. But once I made the decision and gave myself permission, I've never regretted it.

IT'S UP TO YOU

You are creative. You have the freedom to decide your medium, your subject, and which projects you pursue. If you haven't already, give yourself permission and GO FOR IT!

DON'T GIVE UP

When discouragement bubbles over, remember this is a creative journey—not a destination. Even if you wish you were in a better "place," this is just a stop on the journey. KEEP GOING. Don't quit.

There are ups and downs in every creative practice. Stick with it through the difficult times. Know that an "up time" will follow. You never know how high you'll climb!

Creative Tip

CELEBRATE

Don't forget to celebrate your accomplishments — whether it's 15 minute creative session, a final piece, or going outside of your comfort zone and experimenting with a new medium.

I'd love to get your feedback on your Creative Exploration experience – email me at lidesigner@yahoo.com.

Continue your creative journey at: eileenmckenna.com/shop

CONGRATULATIONS! YOU DID IT!

Made in the USA
Middletown, DE
27 January 2021